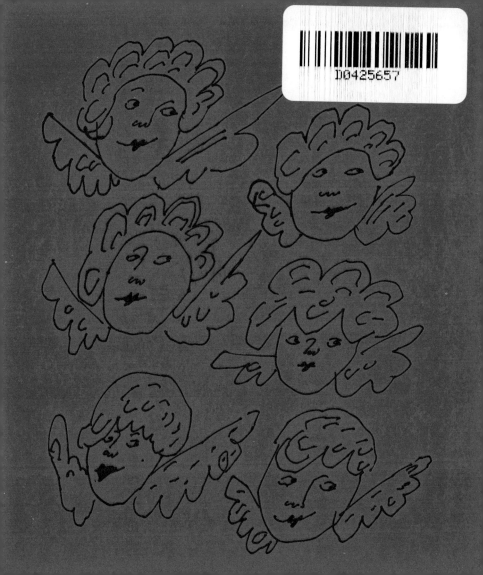

D0425657

ANGELS, ANGELS, ANGELS

ANGELS, ANGELS, ANGELS

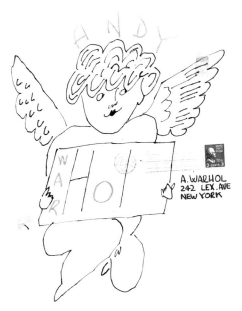

ANDY WARHOL

A BULFINCH PRESS BOOK

LITTLE, BROWN AND COMPANY BOSTON NEW YORK TORONTO LONDON

First Edition
Second Printing, **1995**
Quotes compiled by R. Seth Bright
Designed by John Kane

Library of Congress Cataloging-in-Publication Data

Warhol, Andy, 1928–1987
 Angels, angels, angels / Andy Warhol. — 1st ed.
 p. cm.
 "A Bulfinch Press Book"
 ISBN 0-8212-2131-0
 1. Warhol, Andy, 1928–1987 – Catalogs. 2. Warhol, Andy,
1928–1987 – Quotations. 3. Angels in art. I. Title.
NC139.W37A4 1994a
741.973 – dc20 94-14069

Bulfinch Press is an imprint and trademark of
Little, Brown and Company (Inc.)
Published simultaneously in Canada by
Little, Brown & Company (Canada) Limited

PRINTED IN SINGAPORE

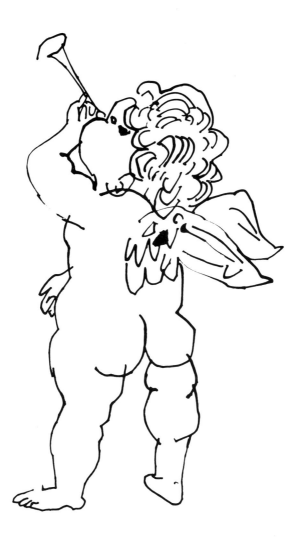

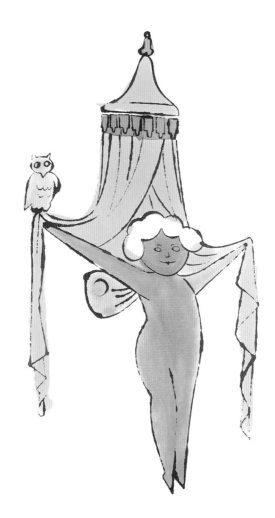

The world fascinates me.

It's so nice,

whatever it is.

I broke something today,

and I realized
 I should break
 something

once a week...

to remind me how

fragile

life

is.

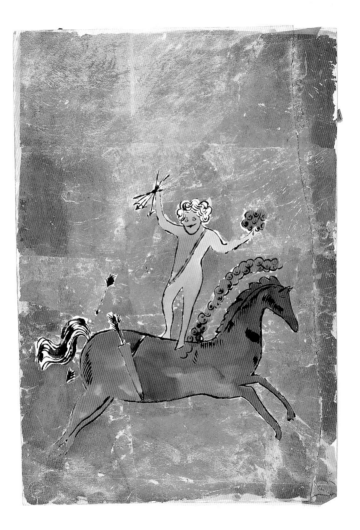

You just **can't** do things that you're not the type to do.

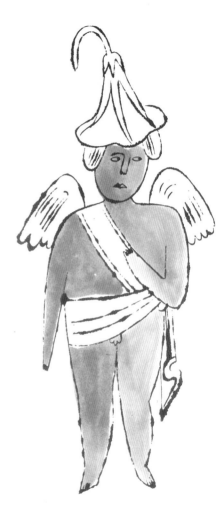

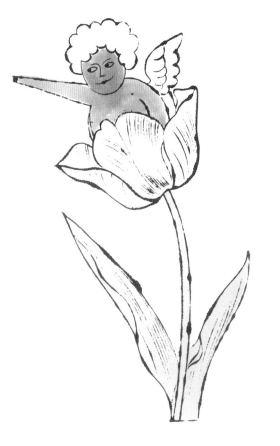

You *can* say things that
you're not the type to say,
though.

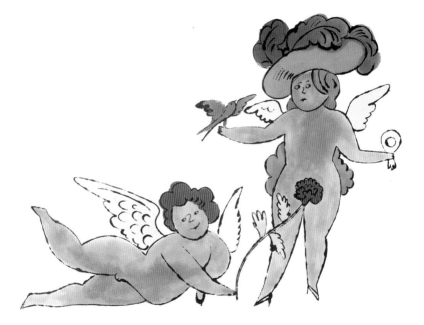

If everybody's
not a beauty,

then
nobody
is.

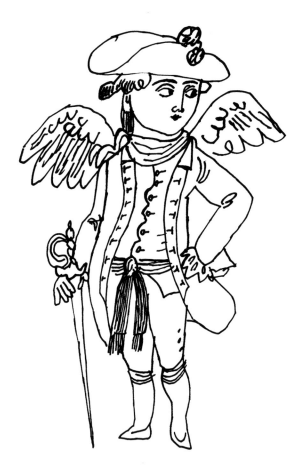

Everyone is rich, everyone is interesting.

There should be a lot of

new girls in town

and there always are.

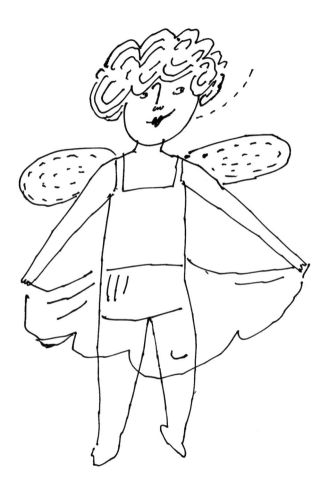

I think that's the best thing in life—

keeping
busy.

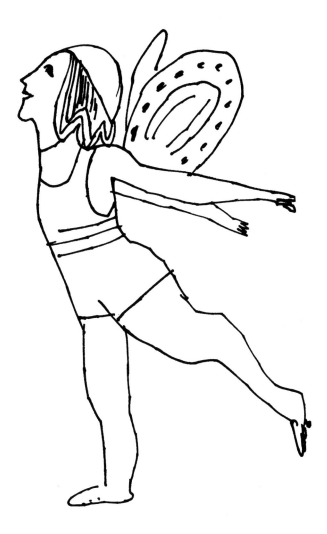

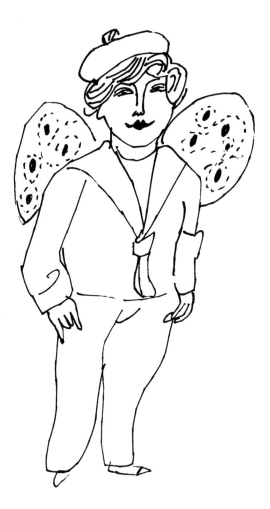

People have so many problems with love,

always looking for someone to be...

their

soufflé

that

can't

fall.

I've never met a person

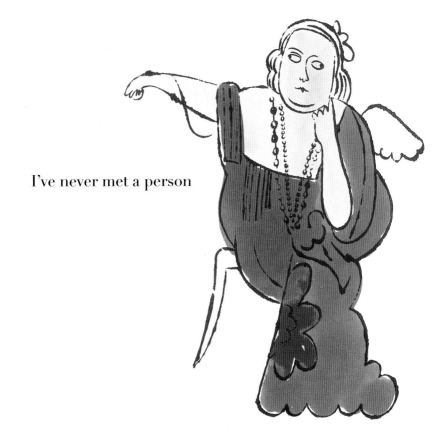

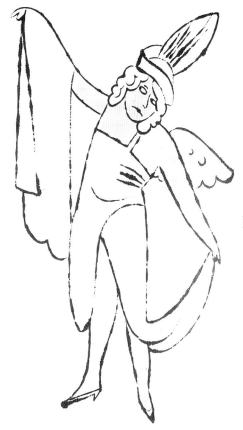

I couldn't call a beauty.

People look the most kissable

when
they're not wearing
makeup.

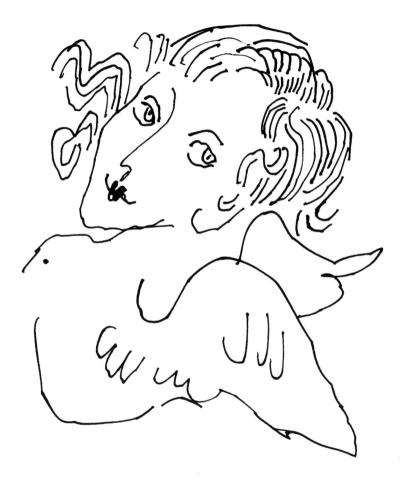

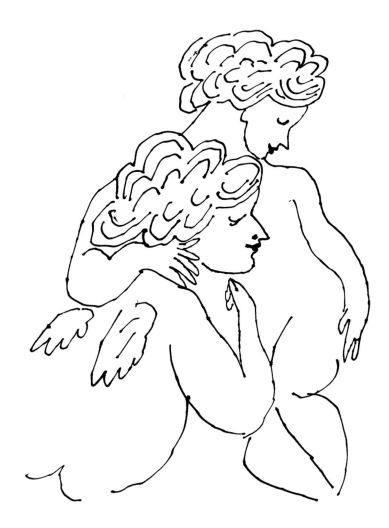

Style

isn't really important.

I approve of what everybody does.
It must be right because somebody said it was right.

I wouldn't judge
anybody.

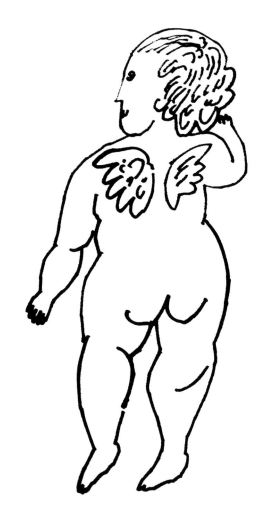

People would like you
even more
for being **strong enough** to say you were

different

and actually have fun with it.

The most exciting attraction

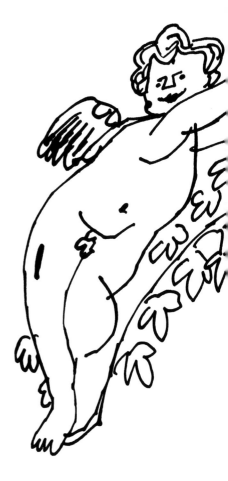

...re between two opposites that never meet.

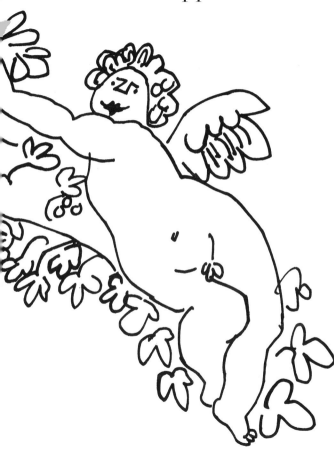

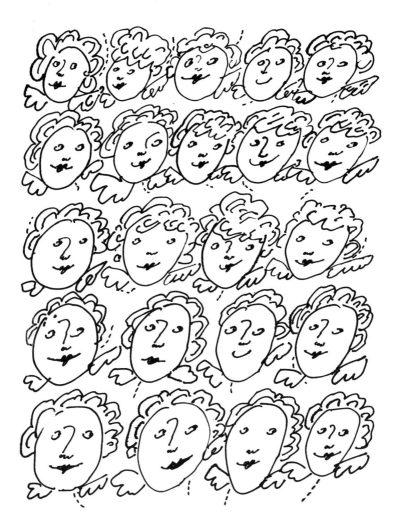

Some day everybody will think

just
what
they
want
to
think.

I'm really afraid to feel happy

because

it never

lasts.

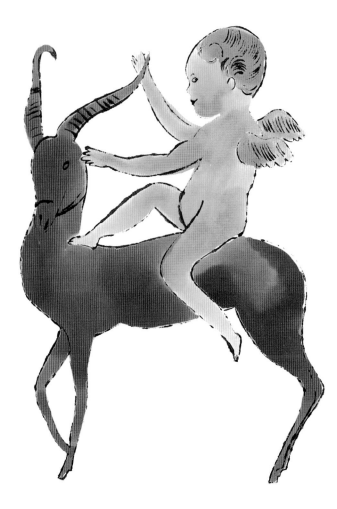

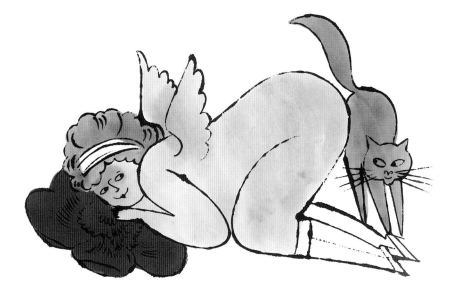

Beauty really has to do with the way a person carries it off.

I just like everybody

and I believe in
everything.

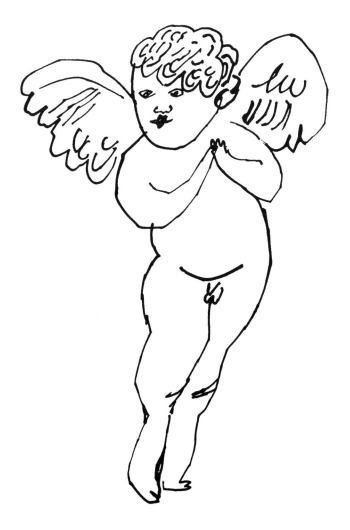

Who
am
I?

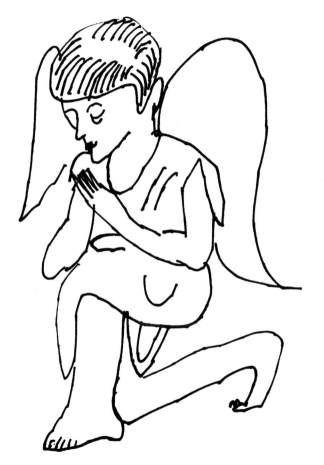

What
should
I do?

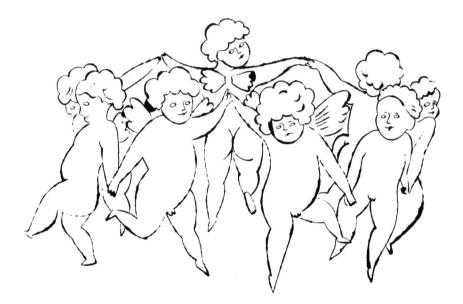

The most memorable thing

for me during an around-the-world trip that I took once was walking along a trail in Bali and finding a bunch of people having a big happy party, and it turned out their friend had died and they were so thrilled for him that he was now having his next life.

When **people**

are ready to,

they **change.**

They never do it

before then.

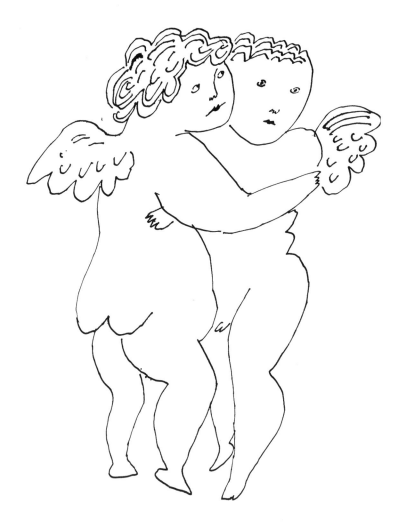

Heaven and Hell

are just

one breath

away.

That was
the whole
idea—

two people
getting acquainted.

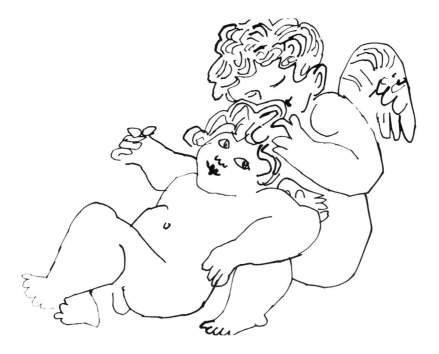

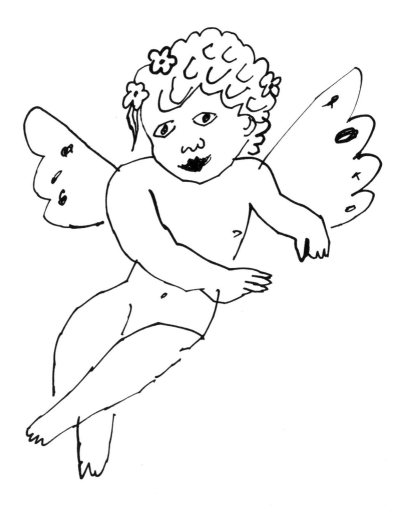

You have to hang on in periods when your style isn't popular, because if it's good, it'll come back, and you'll be a

recognized beauty

once again.

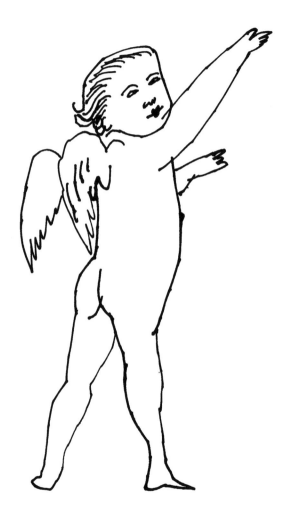

They always say that time changes things, but you actually have to

change them yourself.

It's more fun to be with people who are doing things.

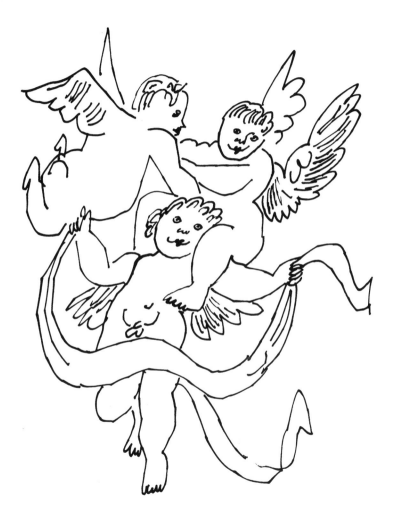

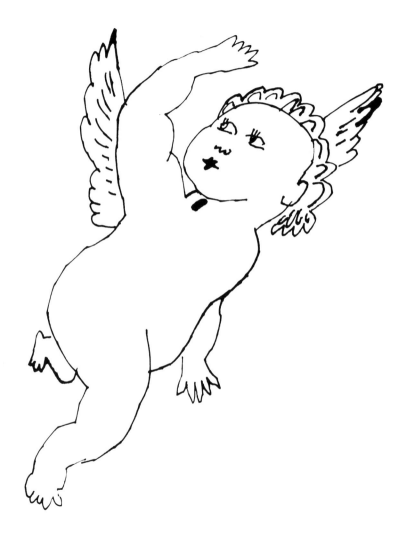

Everybody
has problems,

but the thing is
to not make a **problem**
about your
Problem.

You can never be sure about death...

because you're not around to know that it has happened.

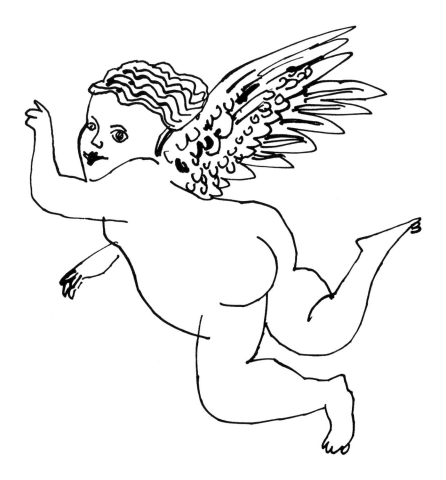

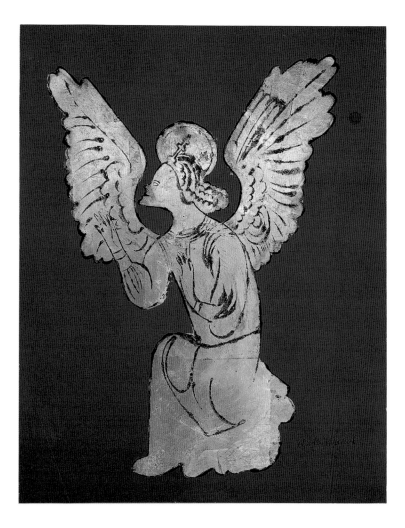

But all you had to do was know you were in the future, and that's what put you there. The mystery was gone, but the amazement was just starting.

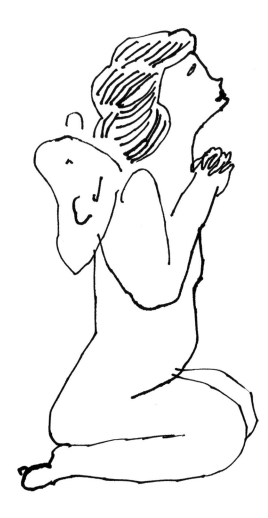

My philosophy is that

every
day's
a
new
day.

Every
minute
is like the first minute
of my life.

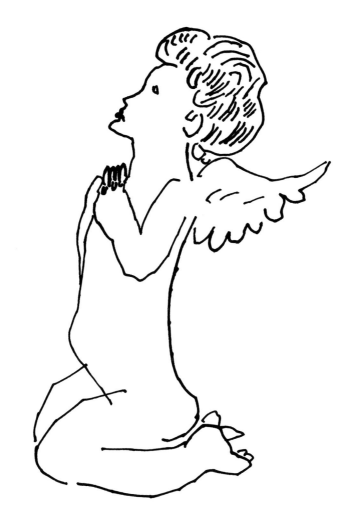

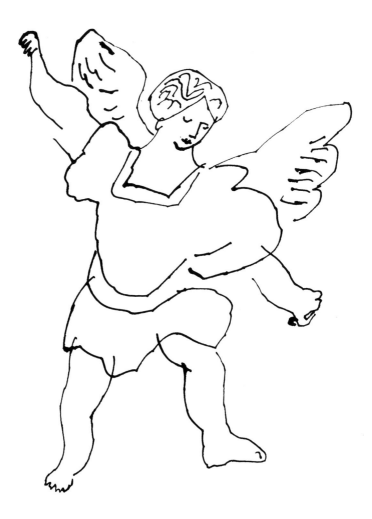

If a person isn't generally considered beautiful, they can still be a success if they have a few jokes in their pockets.

And a lot of pockets.

...nature changes things and

carbon is turned into
diamonds and

dirt is
gold...

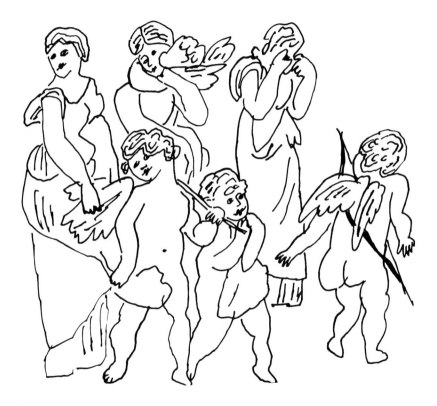

All quotes are by Andy Warhol
and were first published as follows:

Pages 13, 16, 21, 22-23, 24, 32-33, 39, 53, 55, 56, 59, 66, 69, 70:
 Andy Warhol. *The Philosophy of Andy Warhol (from A
 to B and Back Again)*. New York: Harcourt Brace
 Jovanovich, 1975.

Pages 42-43:
 Andy Warhol. *America*. New York: Harper & Row, 1985.

Page 45:
 Andy Warhol and Pat Hackett. *Andy Warhol's Party
 Book*. New York: Crown Publishers, 1988.

Pages 7, 8, 10-11, 15, 18, 27, 28, 31, 35, 36, 40, 46-47, 49, 50, 60, 63, 65:
 Mike Wrenn. *Andy Warhol: In His Own Words*.
 London: Omnibus Press, 1991.

Captions by page number

Cover
Page from "In the Bottom of My Garden," 1955
Offset print, hand-colored

Endpapers
Fairy Faces with Wings, c. 1954
Ink on tan paper
11 3/4" by 8 7/8"

3 *Nude Fairy with Wings*, c. 1954
Ink on peach paper with orange crayon and postage stamp
11 7/8" x 8 7/8"

5 *Fairy with Wings*, c. 1954
Black and brown ink on ivory bond paper
10 7/8" x 8 1/2"

6 *Fairy ("In the Bottom of My Garden")*, 1955
Hand-colored offset
8 1/2" x 11 1/4"

9 *Cupid on Horseback*, c. 1955
Gold leaf, ink, Dr. Martin's Aniline Dye, and stamped gold on Strathmore paper
23" x 15 7/8"

10-11
Two Fairies ("In the Bottom of My Garden"), 1955
Hand-colored offset
8 1/2" x 11 1/4"

12 *Two Fairies ("In the Bottom of My Garden")*, 1955
Hand-colored offset
8 1/2" x 11 1/4"

14 *Fairy with Wings*, c. 1954
Ink on ivory bond paper
11" x 8 3/8"

17 *Fairy with Wings*, c. 1954
Ink on paper
11 3/4" x 8 7/8"

19 *Fairy with Spotted Wings*, c. 1954
Ink on paper
11" x 8 1/2"

20 *Fairy with Spotted Wings,*
 c. 1954
 Ink on paper
 11" x 8 1/2"

22-23
 *Two Fairies ("In the Bottom of
 My Garden"),* 1955
 Hand-colored offset
 8 1/2" x 11 1/4"

25 *Fairy with Wings,* c. 1953
 Ink on white bond paper
 11" x 8 1/2"

26 *Two Fairies,* c. 1954
 Ink on tan paper
 11 3/4" x 8 7/8"

29 *Angel,* c. 1959
 Ink and tempera on
 Strathmore paper
 28 5/8" x 22 5/8"

30 *Nude Fairy with Wings,* c. 1954
 Black and brown ink on ivory
 bond paper
 11" x 8 1/2"

32-33
 Nude Fairies with Wings, c. 1954
 Ink on white bond paper
 8 3/8" x 11"

34 *Fairy Faces with Wings,* c. 1954
 Ink on tan paper
 11 3/4" x 8 7/8"

37 *Cherub Riding Long Horned
 Ram,* c. 1954
 Ink and Dr. Martin's Aniline
 Dye on Strathmore paper
 23" x 14 1/2"

38 *Fairy ("In the Bottom of My
 Garden"),* 1955
 Hand-colored offset
 8 1/2" x 11 1/4"

41 *Fairy with Wings,* c. 1954
 Black and brown ink on white
 bond paper
 11" x 8 1/2"

43 *Fairy with Wings,* c. 1954
 Ink on ivory bond paper
 11" x 8 1/2"

44 *Fairies ("In the Bottom of My Garden")*, 1955
Offset print
8 1/2" x 11 1/4"

46-47
Three Fairies ("In the Bottom of My Garden"), 1955
Hand-colored offset
8 1/2" x 11 1/4"

48 *Nude Fairies with Wings*, c. 1954
Ink on paper
11 7/8" x 8 7/8"

51 *Nude Fairies with Wings*, c. 1954
Black and brown ink on ivory bond paper
8 3/8" x 11"

52 *Fairy with Wings*, c. 1954
Black and brown ink on ivory bond paper
11" x 8 3/8"

54 *Fairy with Wings*, c. 1954
Ink on ivory bond paper
11" x 8 1/2"

57 *Three Nude Fairies with Wings*, c. 1954
Black and brown ink on ivory bond paper
11" x 8 3/8"

58 *Fairy with Wings*, c. 1954
Ink on ivory paper
11" x 8 1/2"

61 *Fairy with Wings*, c. 1954
Ink on ivory bond paper
11" x 8 1/2"

62 *Untitled*, c. 1957
Ink and gold leaf on paper
20" x 16"

64 *Fairy with Wings*, c. 1954
Ink on ivory paper
11" x 8 1/2"

67 *Fairy with Wings*, c. 1954
Ink on ivory paper
11" x 8 1/2"

68 *Fairy with Wings*, c. 1954
Ink on ivory paper
11" x 8 1/2"

71 *Six Fairies*, c. 1954
 Ink on ivory bond paper
 8 1/2" x 11"

77 *Cupid and Cherubs*, 1956
 Black ballpoint on manila
 paper
 16 3/4" x 13 7/8"

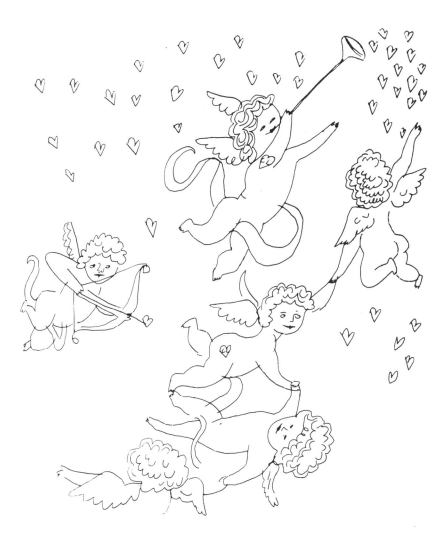

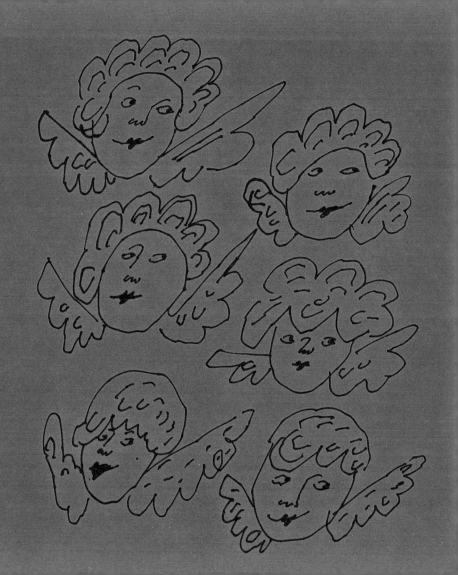